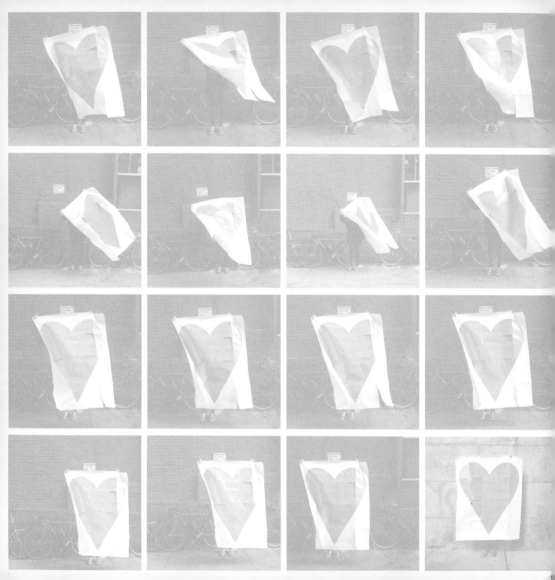

THE ART OF
I LOVE YOU

X O X O

CHRONICLE BOOKS

SAN FRANCISCO

Library of Congress Cataloging-in-Publication Data available.

ISBN: 978-1-4521-1816-1

Manufactured in China.

Designed by Hillary Caudle

10 9 8 7 6 5 4 3

Chronicle Books LLC
680 Second Street
San Francisco, CA 94107
www.chroniclebooks.com

WHAT CAN YOU SAY ABOUT LOVE THAT HASN'T ALREADY BEEN SAID A MILLION TIMES BEFORE, AND BETTER?

Truthfully? Nothing. For as long as we've had words, human beings have been trying to use them to express something that we all know deep-down is far too big—too vast, powerful, and wonderful—too confusing, complicated, and simple—for us to ever really articulate properly. And yet we kept trying and trying. Which means that, by now, at this late stage in the game, the odds of coming up with anything new and original to say about love are as slim as odds can get.

Then again. What were the odds of you meeting and falling in love with the person you find yourself—somehow, mysteriously, magically—together with today? How many twists and turns of fate or chance or luck or screw-up had to happen to land you in each other's arms? *A lot*, that's how many. If something as statistically unlikely as the meeting, connecting, and ultimate coupling of person A and person B out of all the billions of people in the world can happen, then, who knows? Maybe we can find something new to say about love, too. Stranger things have happened. Maybe it's just a question of finding a medium, a material other than words, to carry the meaning.

And that's where our pals, the visual artists, come in. The old adage would have us believe that a picture is worth a thousand words, but per-haps more to the point is that a picture can sometimes capture what even

a thousand words cannot. The subtleties of the body (that slight tilt of the head toward the object of affection, that tiny half smile just because two people are in the same room together); the emblems of attachment (how flowers and chocolates and lacy hearts and rings really can, in our unguarded moments, mean so much to us); the myriad emotional waves we ride (humor, flirtation, wisdom, sensuality, hope, despair, excitement, repose)—all of this and so much more can be captured in an image.

And the artists in this book have done that for us. They are, ever so graciously, ever so lovingly, giving us a visual language. A set of illuminations to hold up—like travelers in a foreign land where we don't speak the language—and point to while we look at our sweeties with yearning eyes that say *this* and *this* and especially *this* is just exactly how I feel about you.

For all the things we want to say but don't, for all the things we know in our hearts but can't express with words, we turn to the images in *The Art of I Love You*. And they reflect and magnify our love, dozens of times over, beautifully.

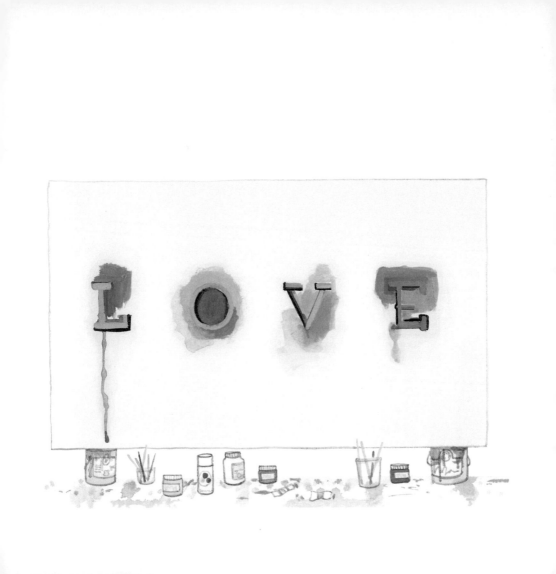

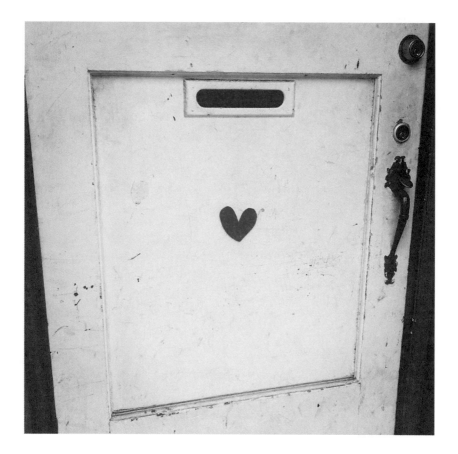

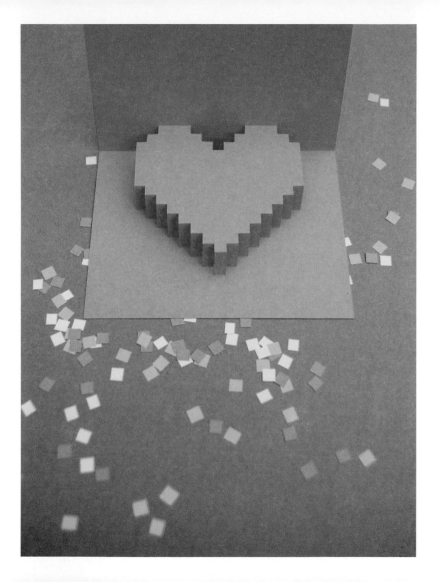

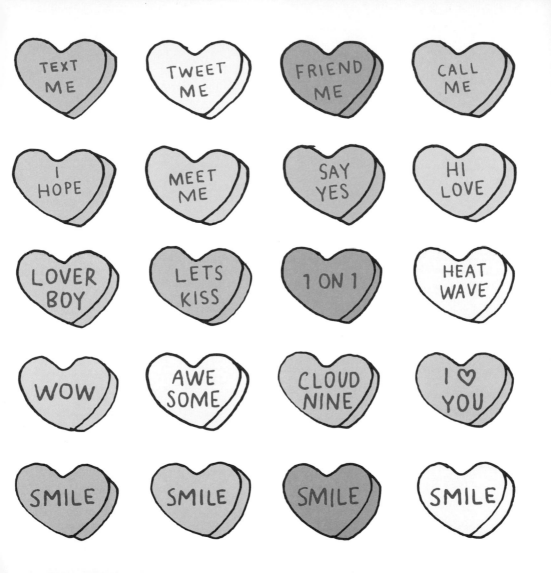

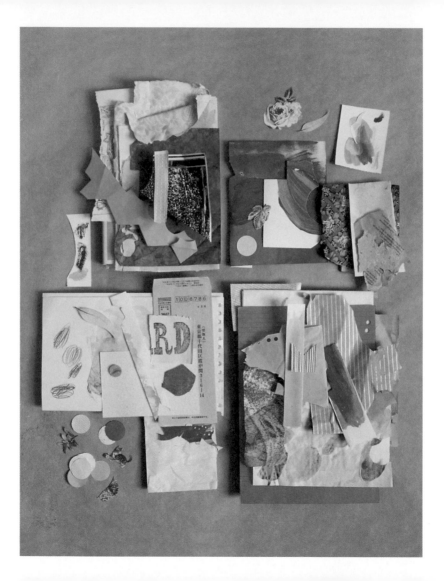

12

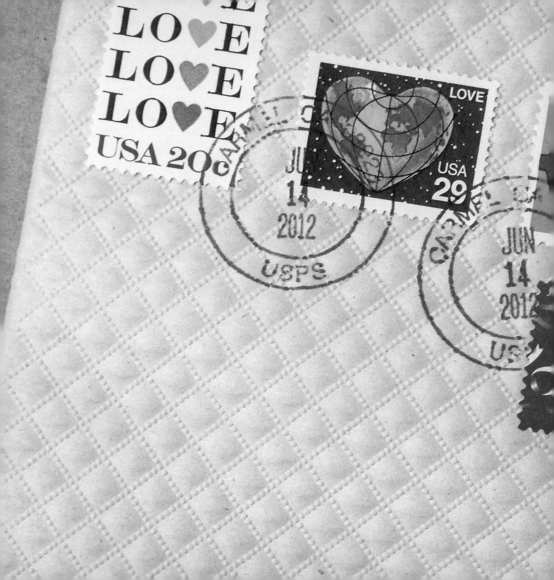

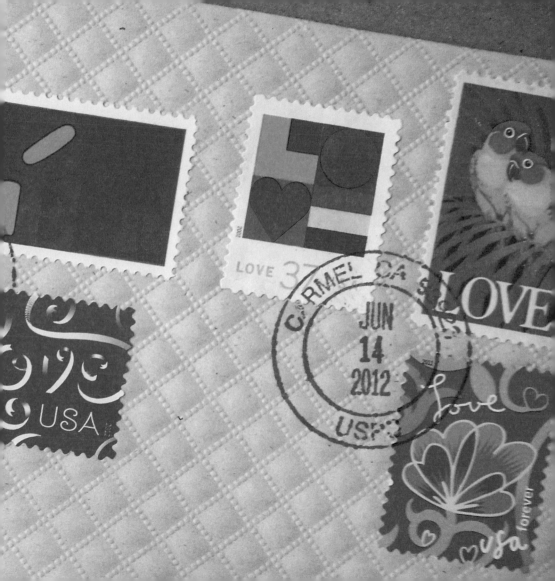

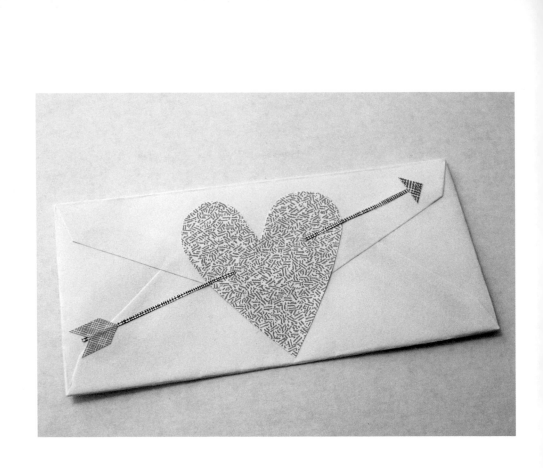

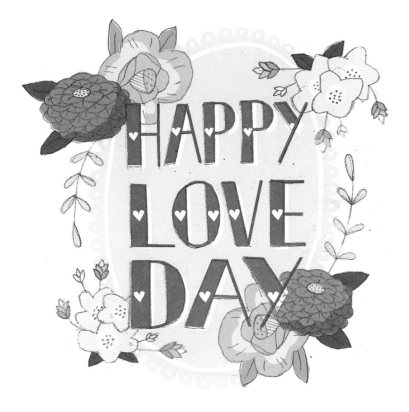

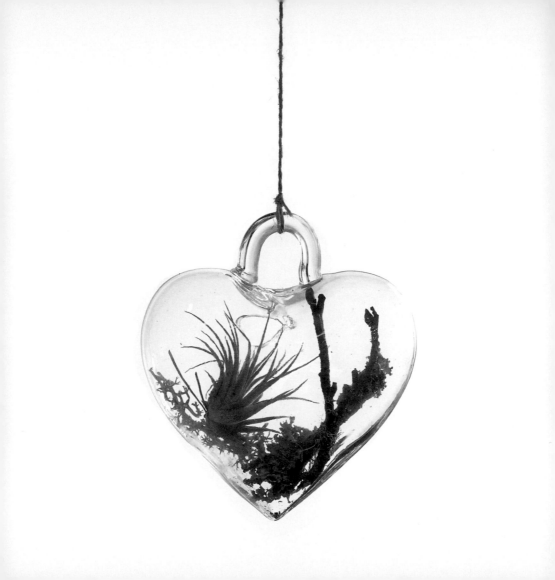

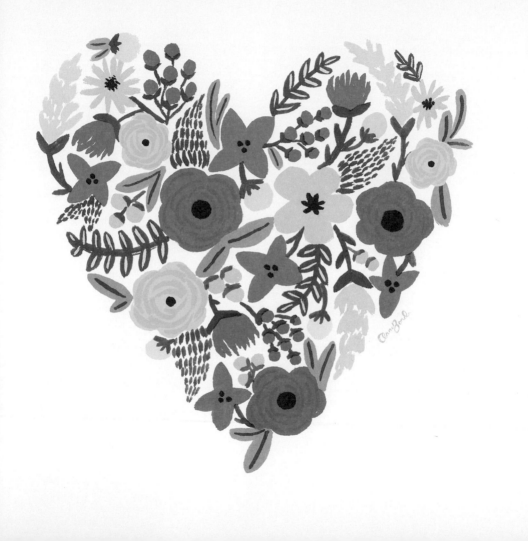

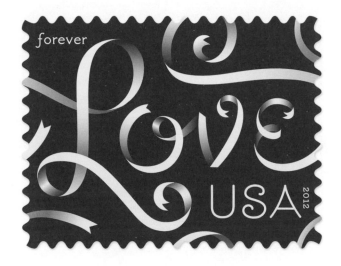

24

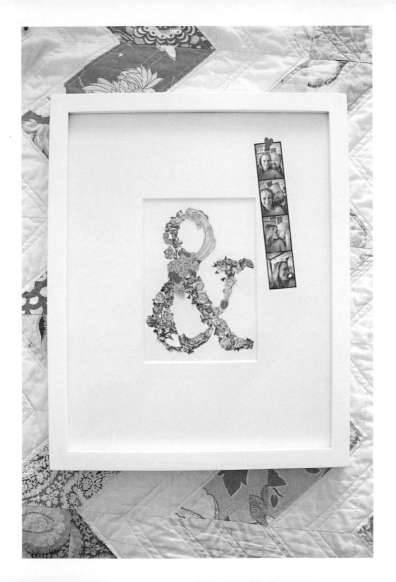

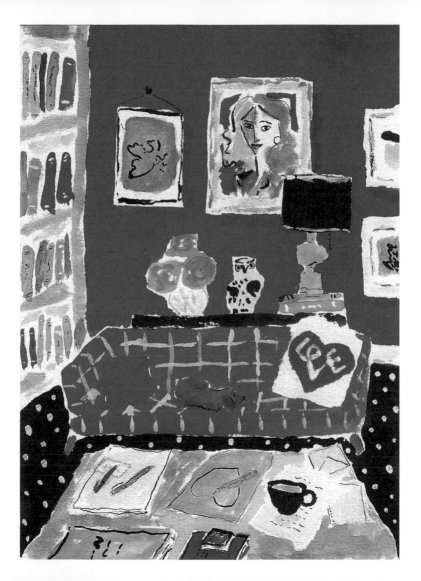

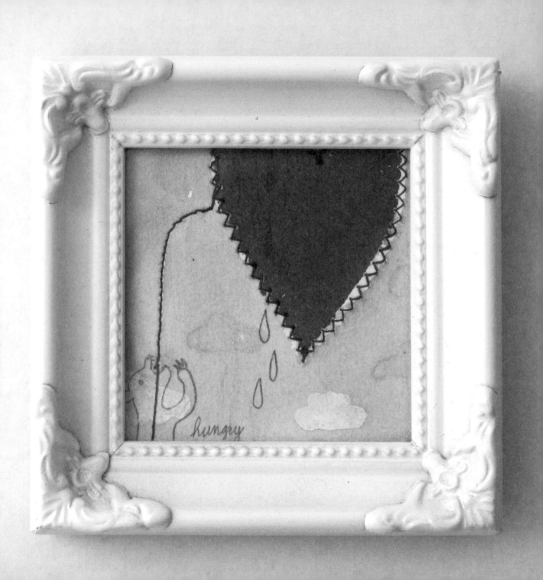

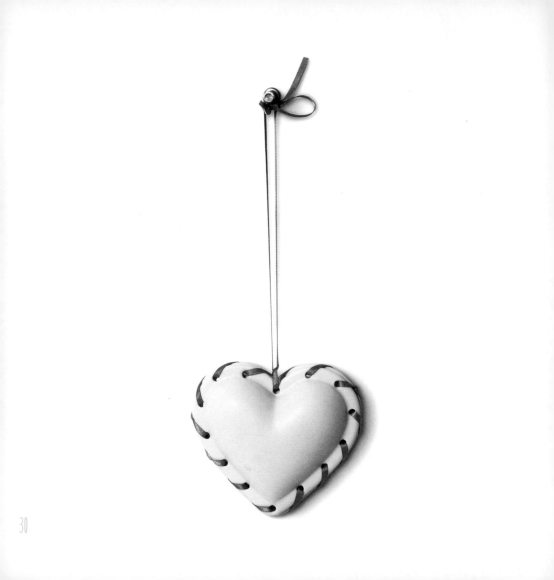

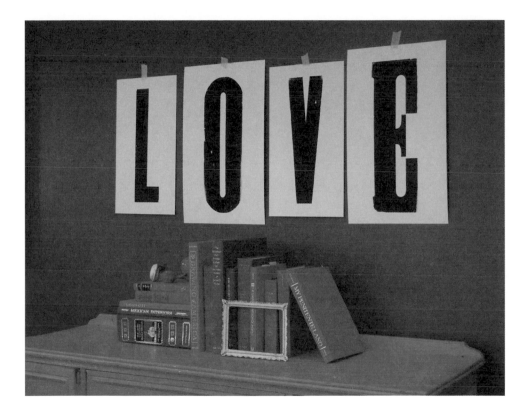

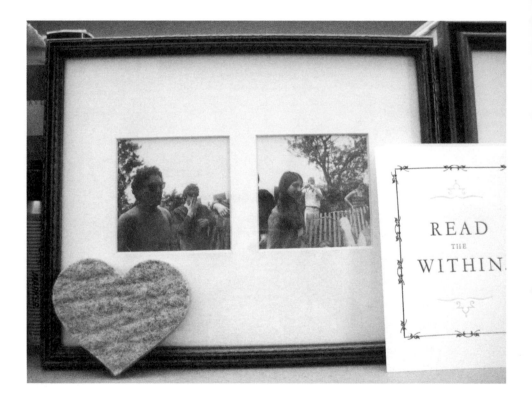

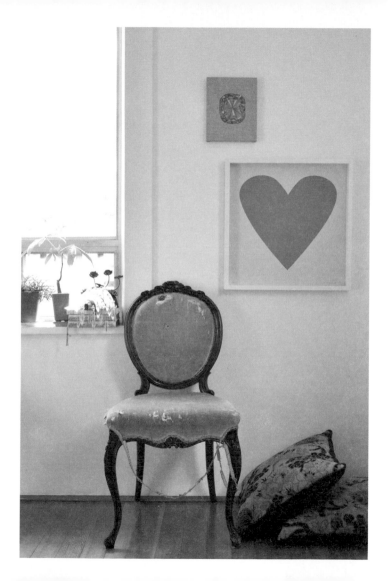

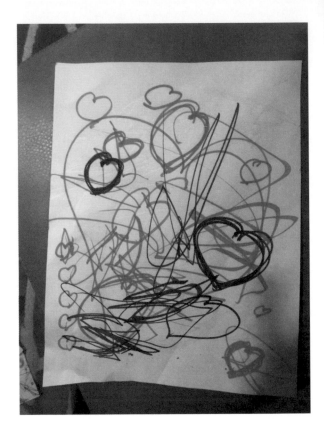

34

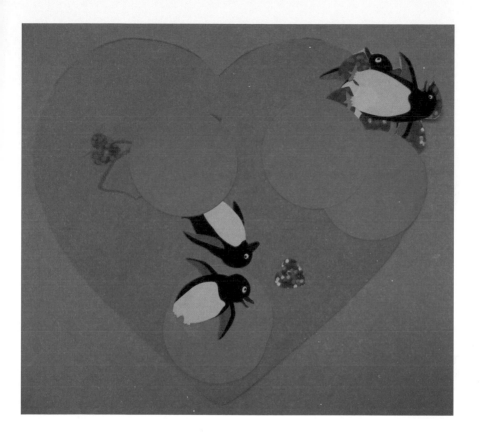

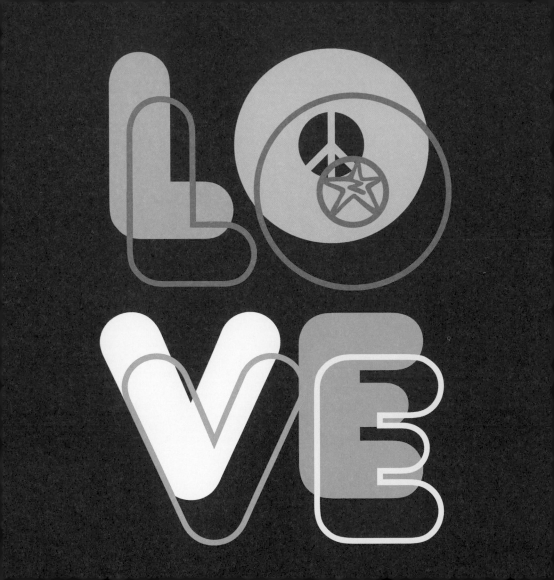

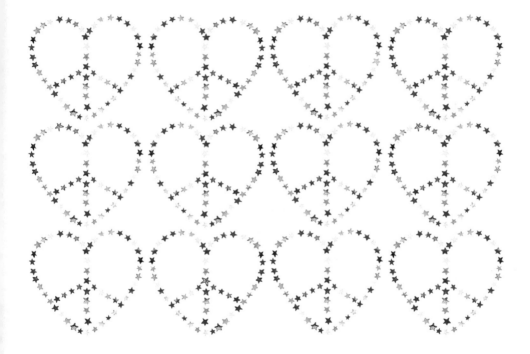

37

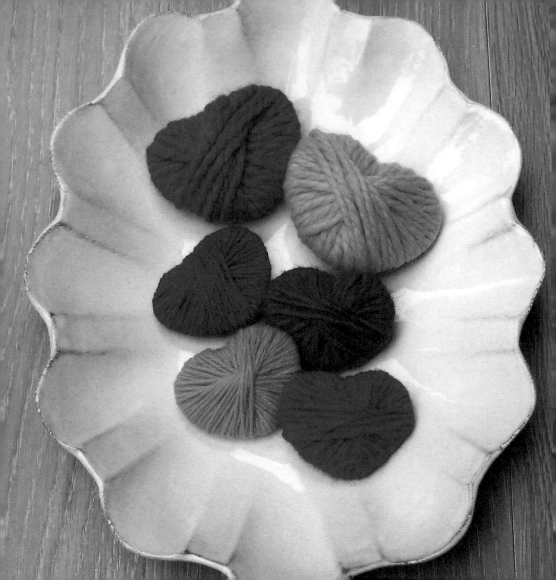

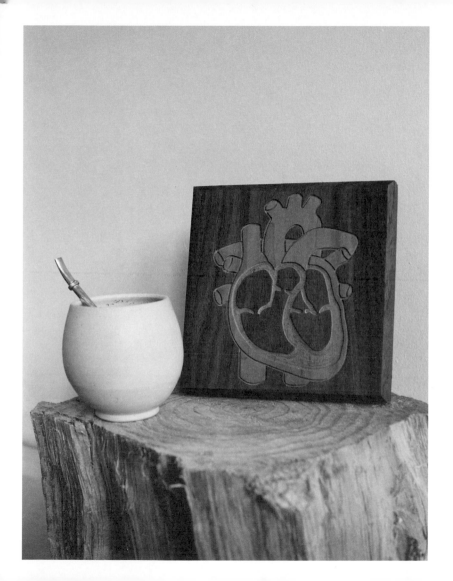

41

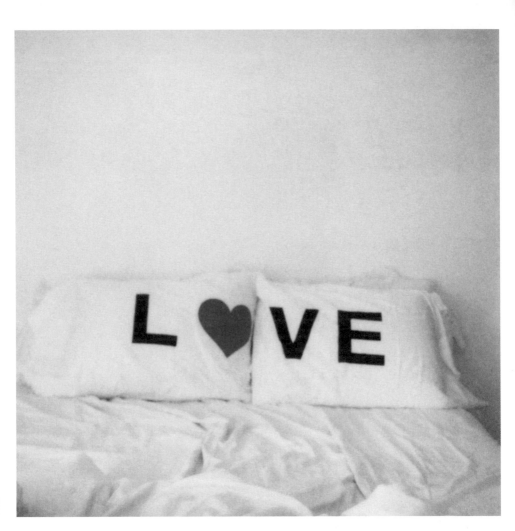

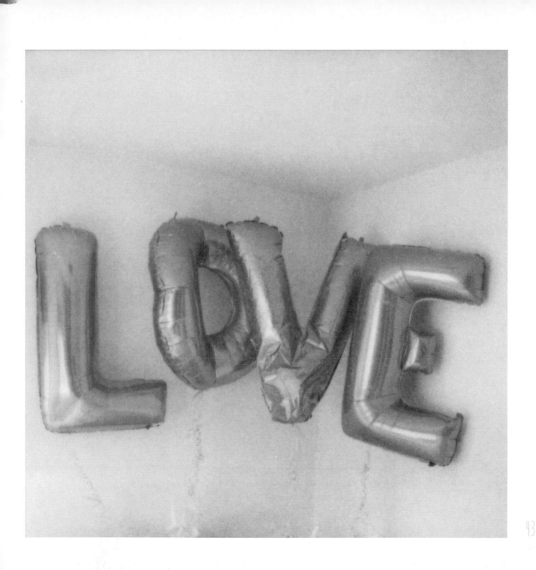

43

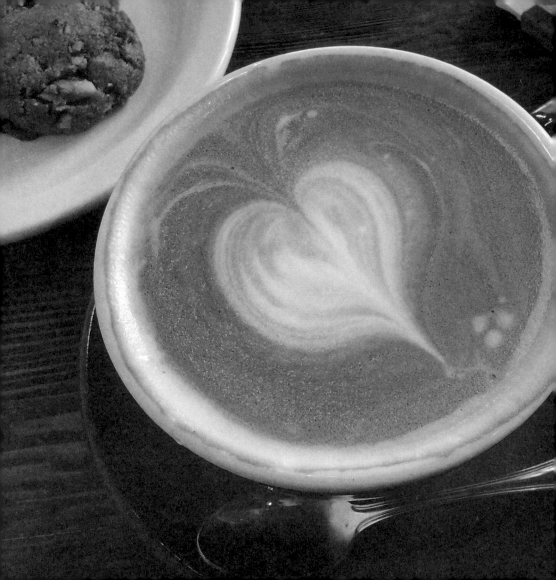

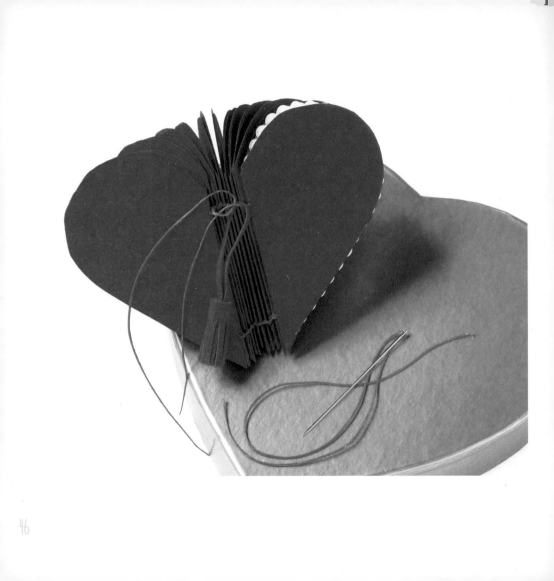

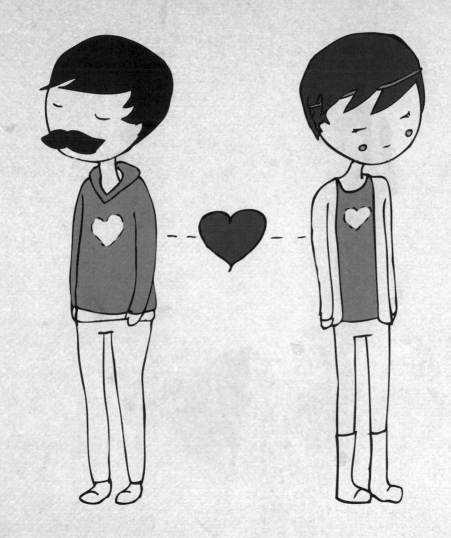

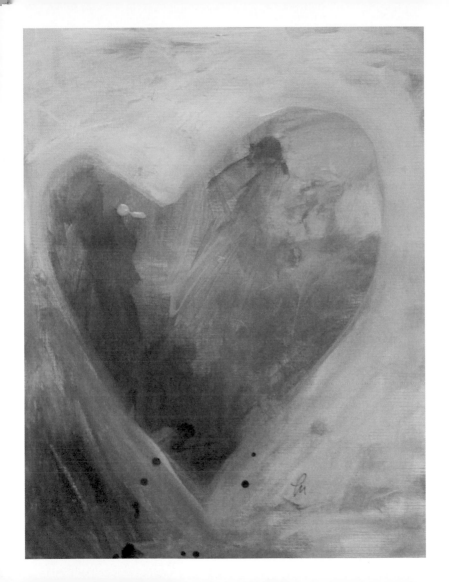

49

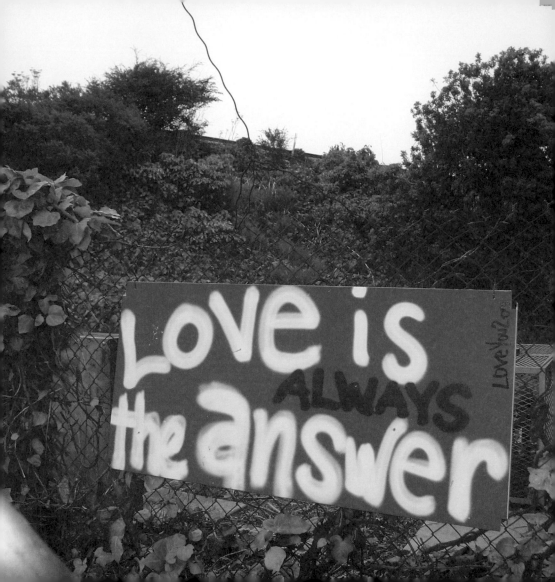

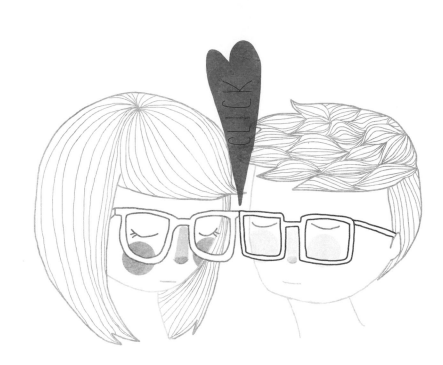

CLICK

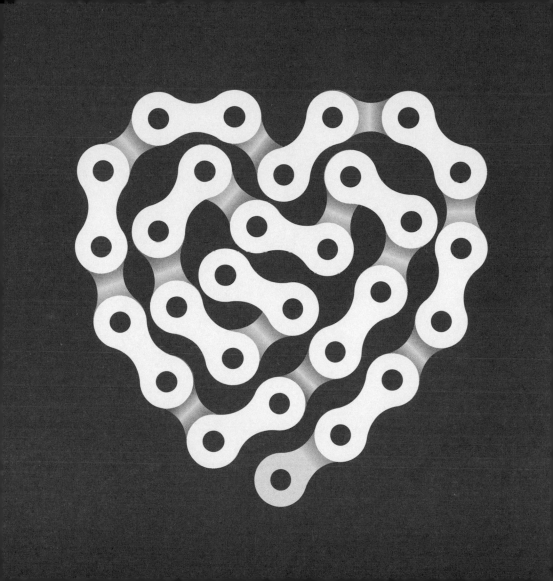

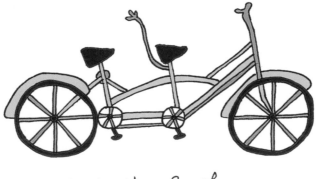

just the 2 of us

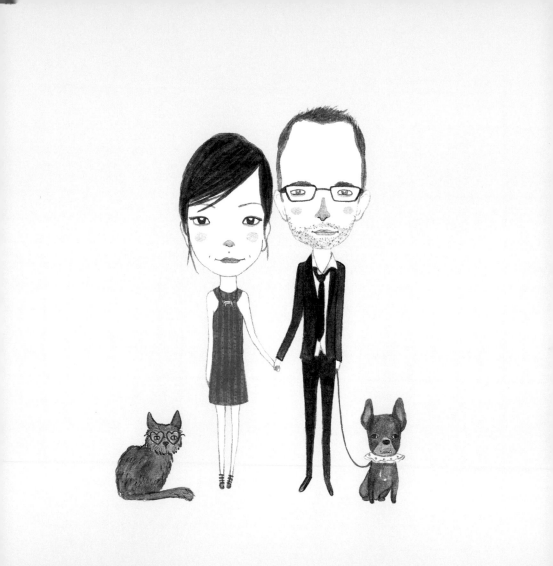

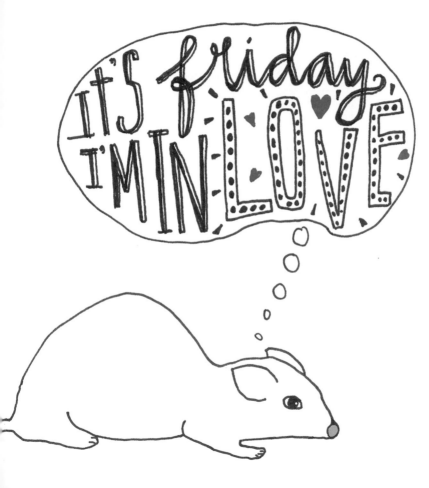

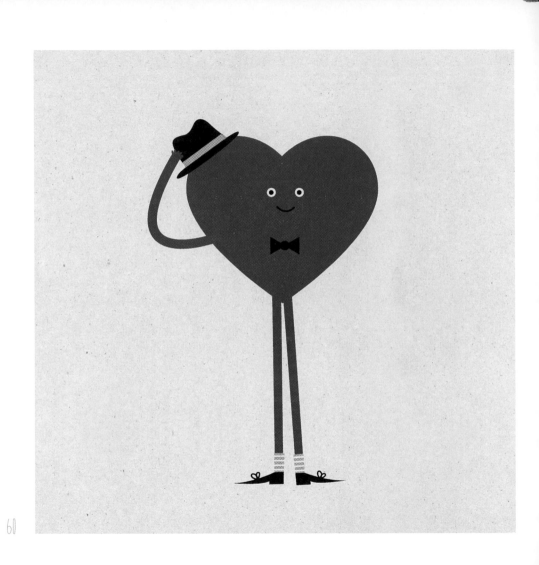

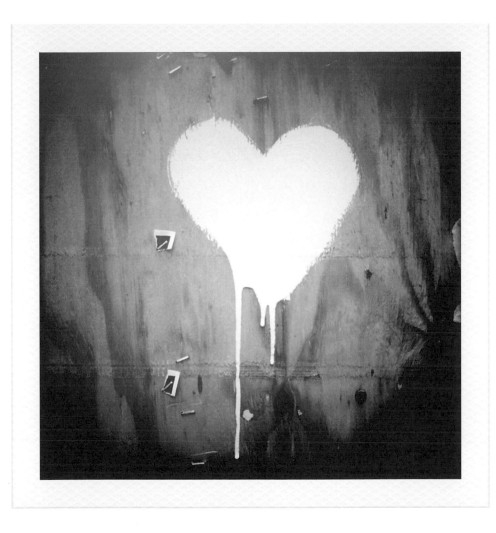

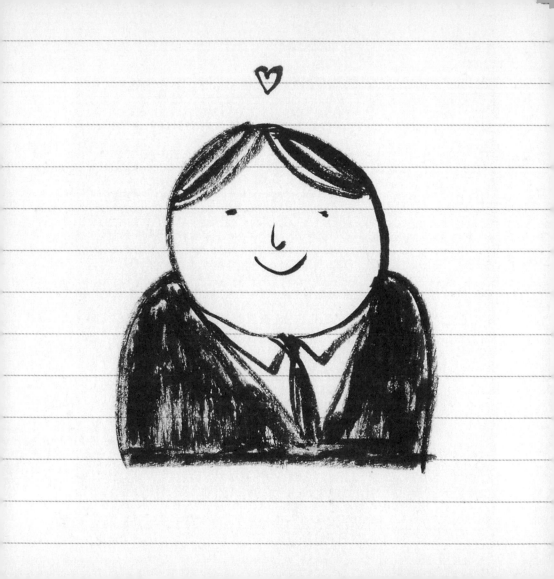

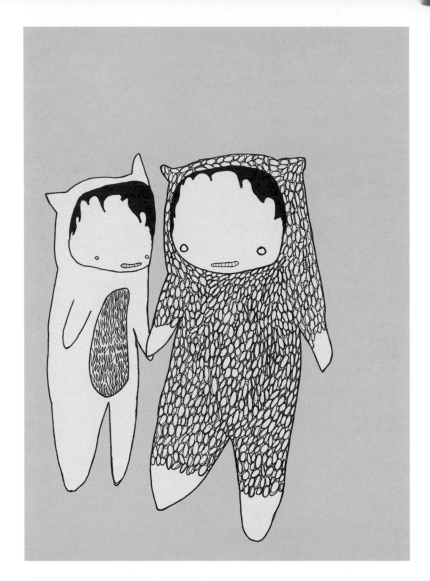

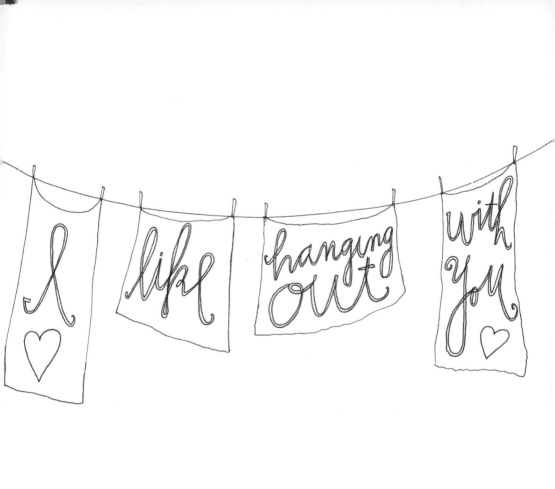

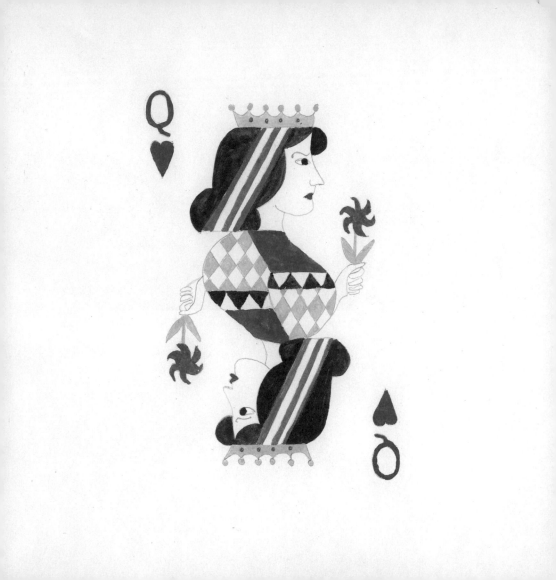

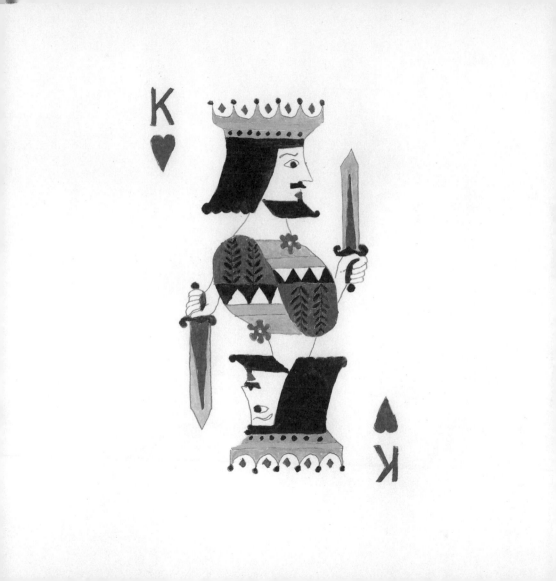

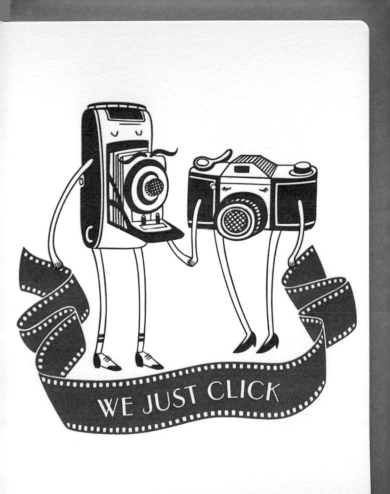

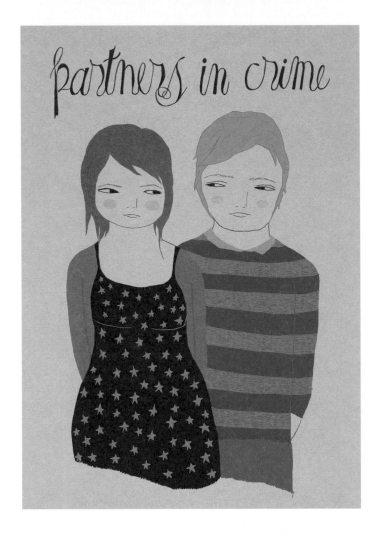

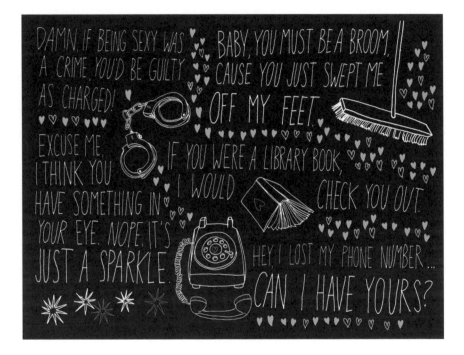

DAMN, IF BEING SEXY WAS A CRIME YOU'D BE GUILTY AS CHARGED!

BABY, YOU MUST BE A BROOM, CAUSE YOU JUST SWEPT ME OFF MY FEET.

EXCUSE ME, I THINK YOU HAVE SOMETHING IN YOUR EYE. NOPE, IT'S JUST A SPARKLE.

IF YOU WERE A LIBRARY BOOK, I WOULD CHECK YOU OUT.

HEY, I LOST MY PHONE NUMBER ... CAN I HAVE YOURS?

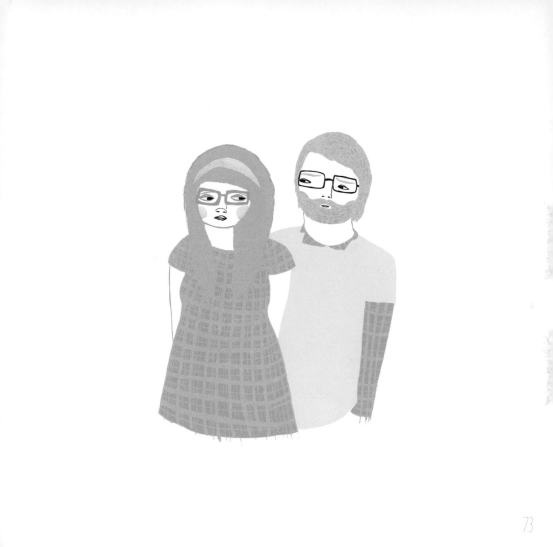

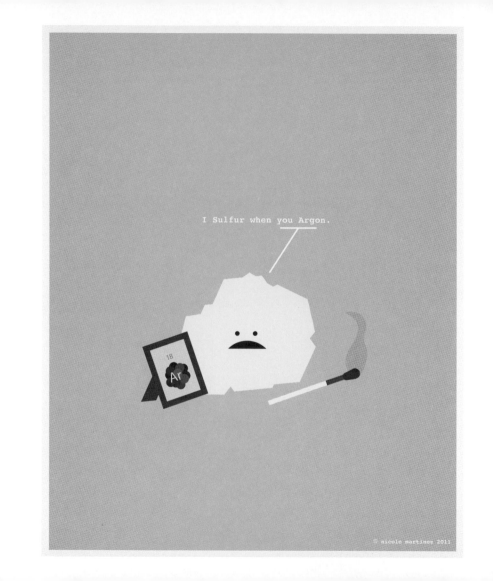

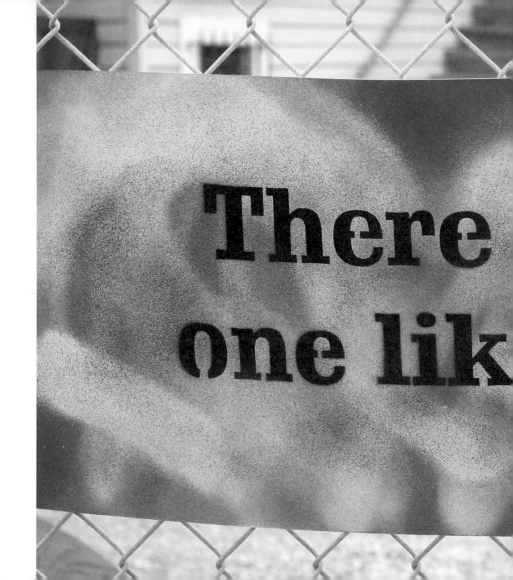

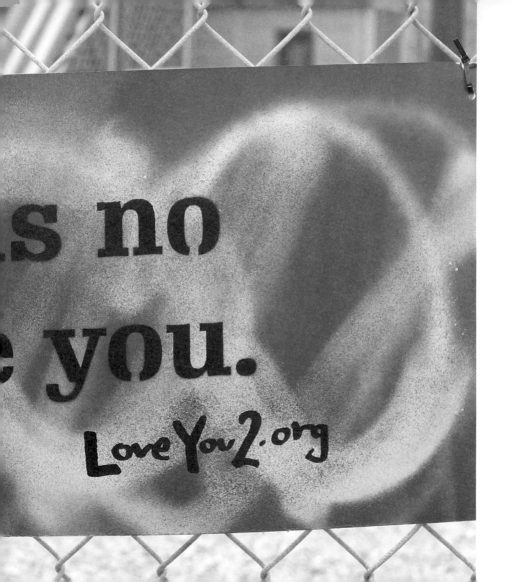

s no

e you.

LoveYou2.org

77

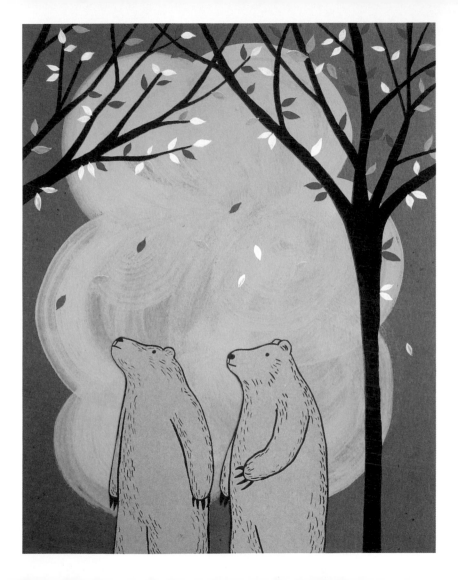

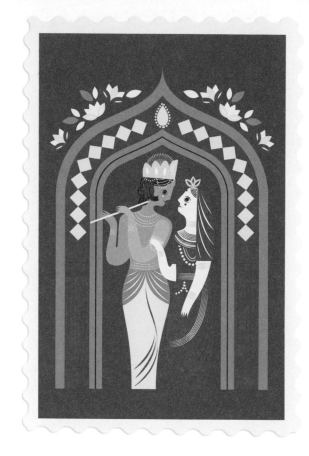

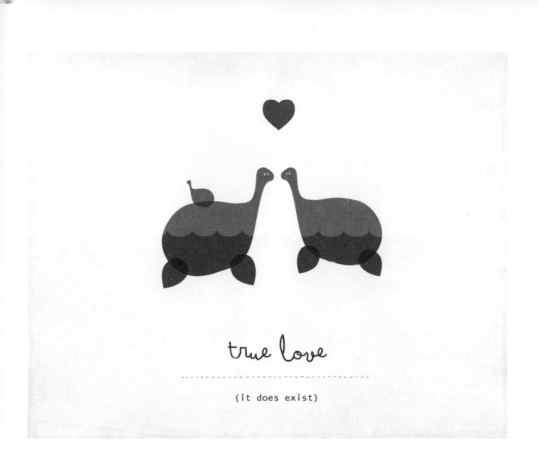

true love

- -

{it does exist}

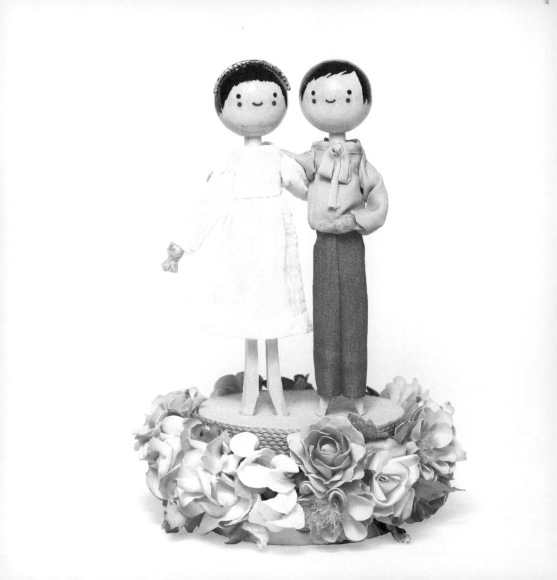

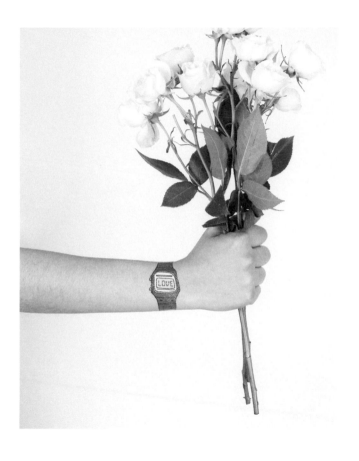

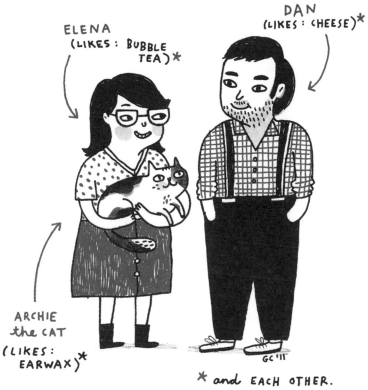

ELENA
(LIKES: BUBBLE
TEA)*

DAN
(LIKES: CHEESE)*

ARCHIE
the CAT
(LIKES:
EARWAX)*

GC '11

* and EACH OTHER.

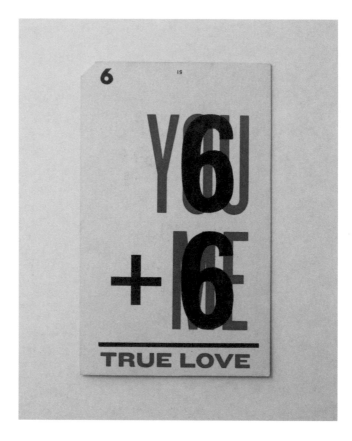

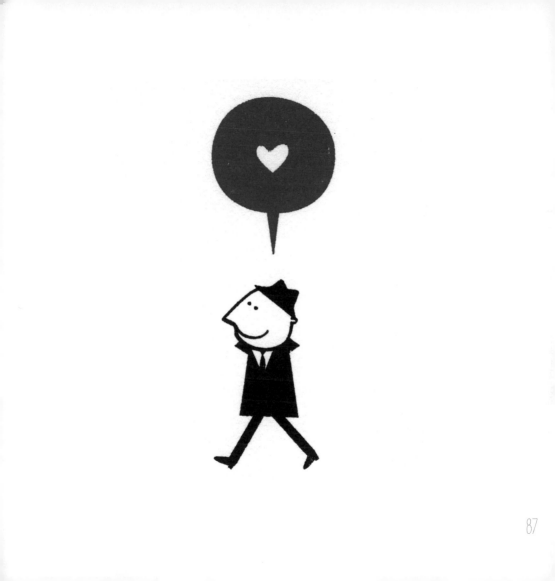

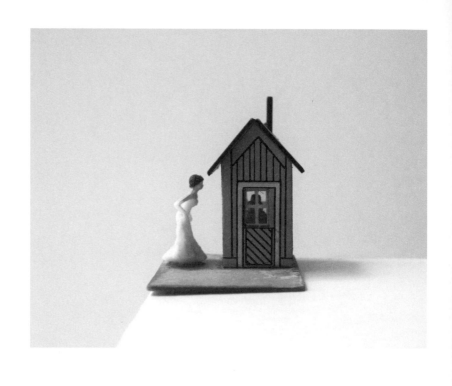

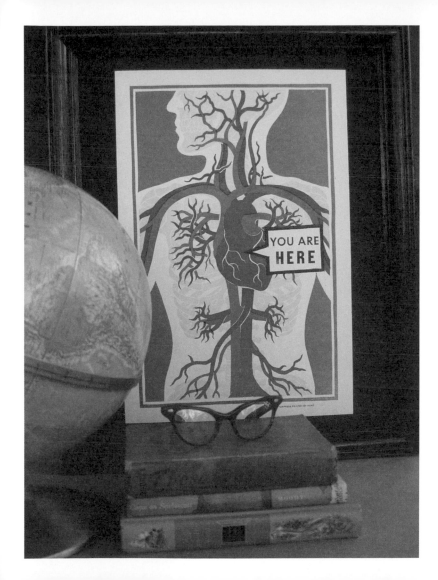

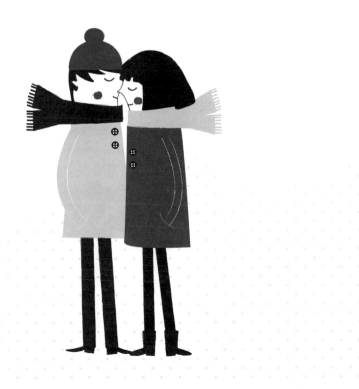

91

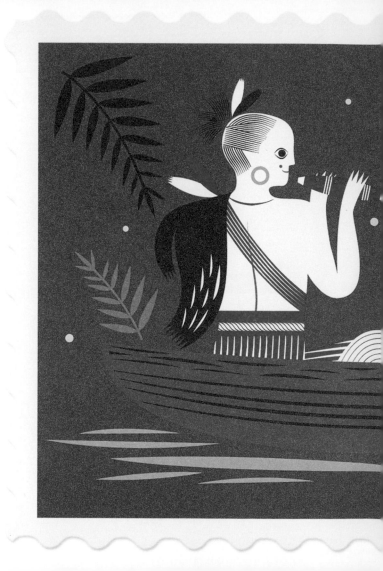

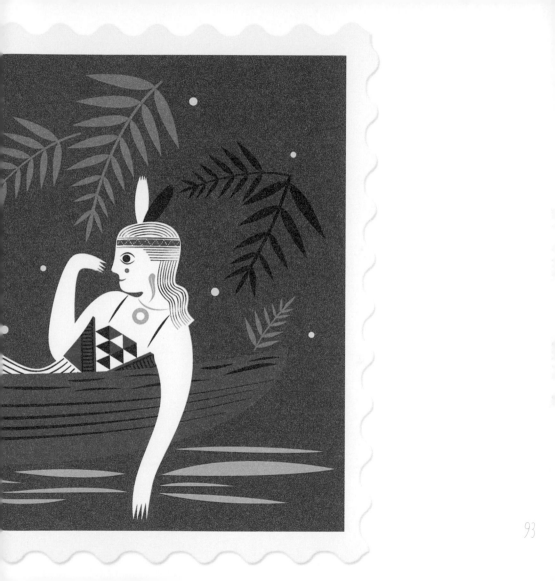

93

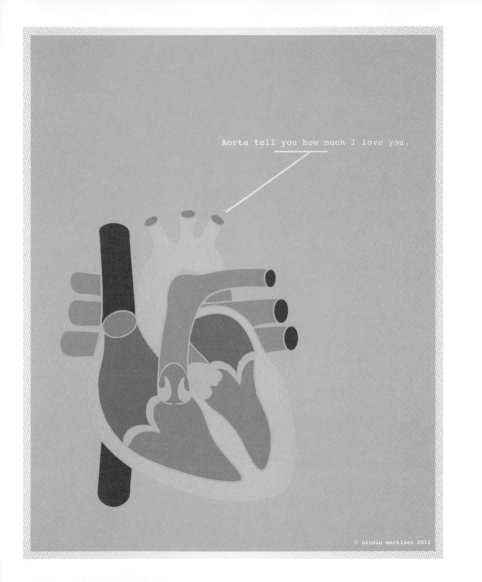

Aorta tell you how much I love you.

95

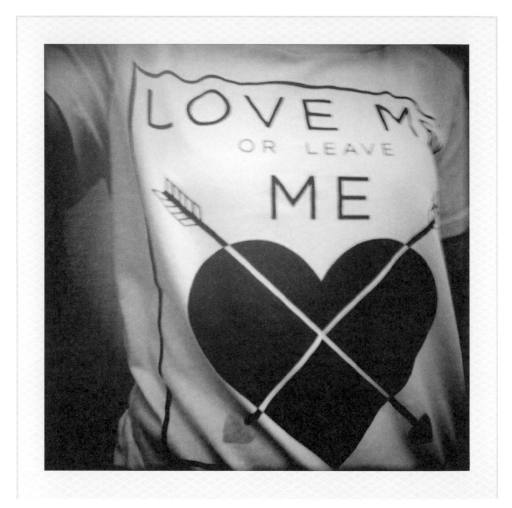

96

I LOVE HIM. OMG I totally love him.
Did you tell him? Does he feel it?
Yeah, I can see it when he looks at me.
And you've said it to each other?
It's so deep, it's like we don't need to
say it. But I think I want to.
You should tell him.

I'm gonna. OMG I can't wait to tell him
I love him.

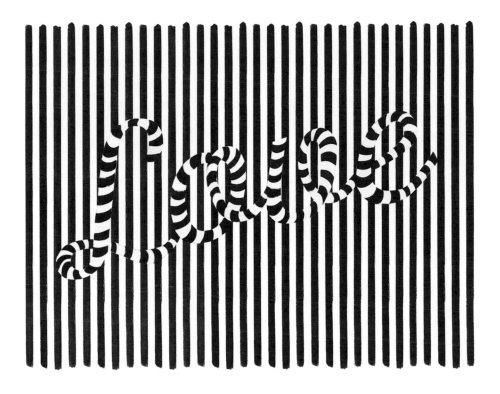

99

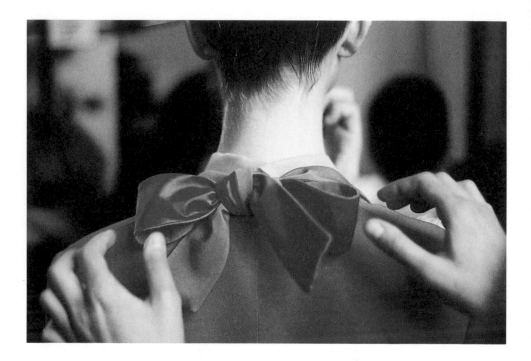

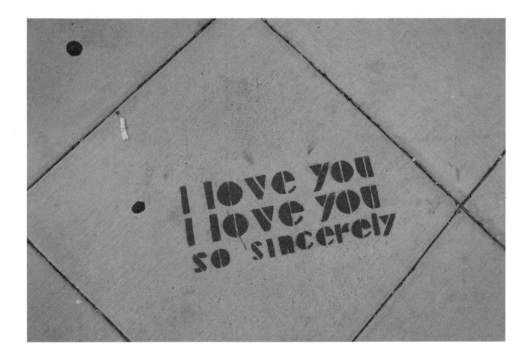

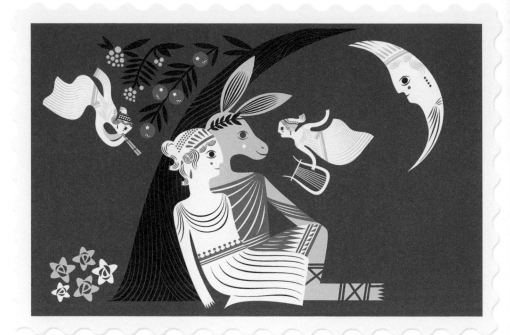

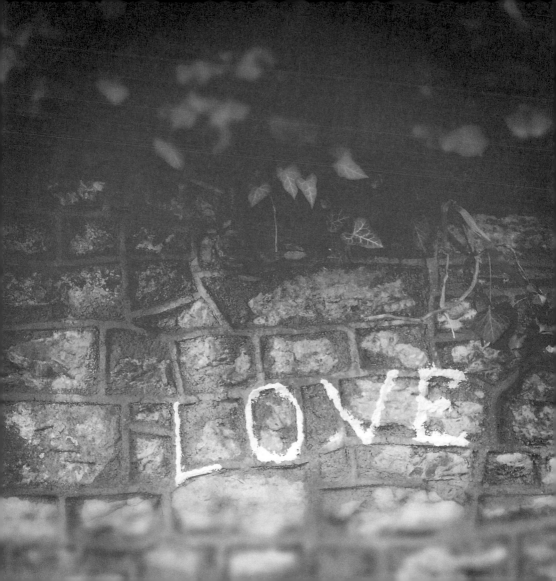

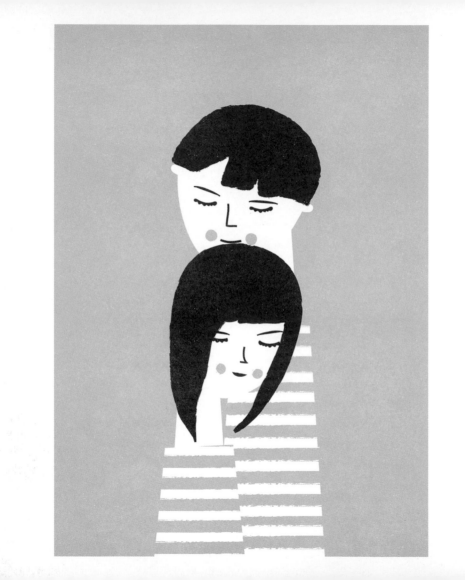

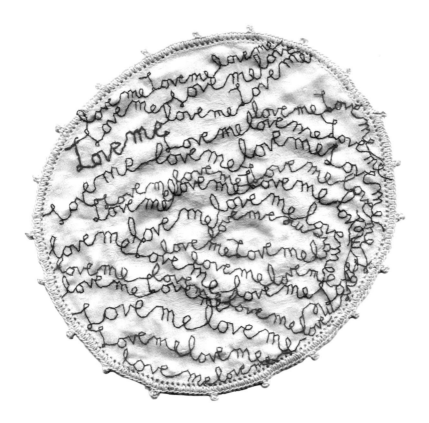

107

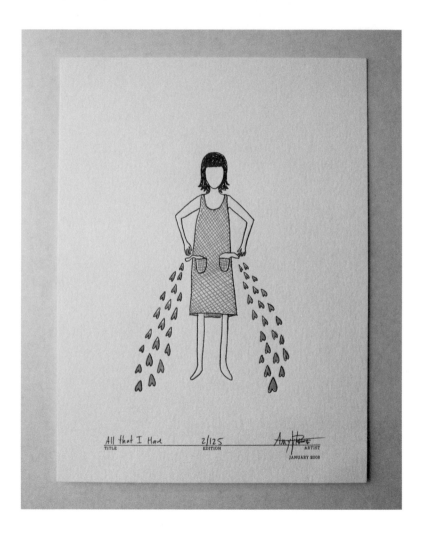

All that I Have
TITLE

2/125
EDITION

Amy Howe
ARTIST
JANUARY 2008

108

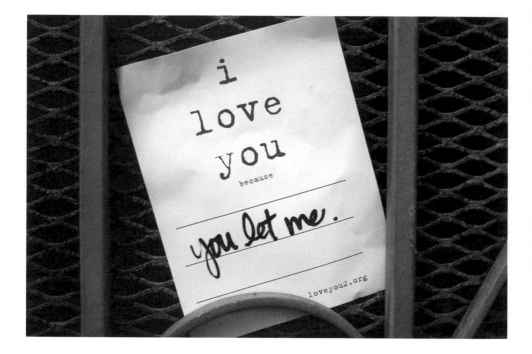

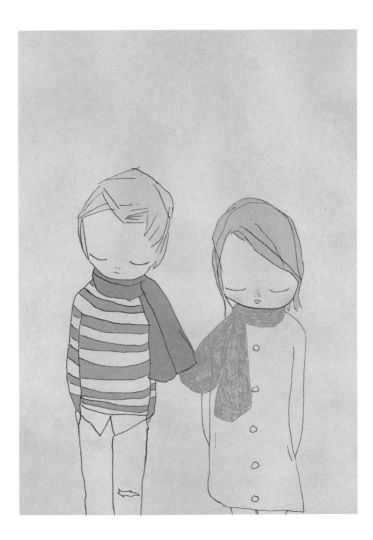

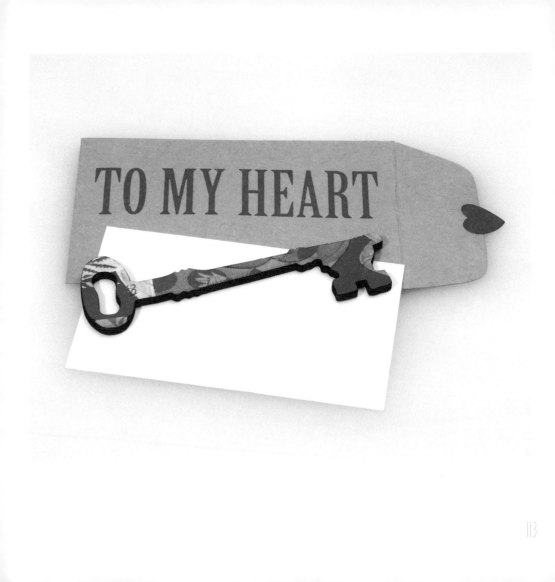

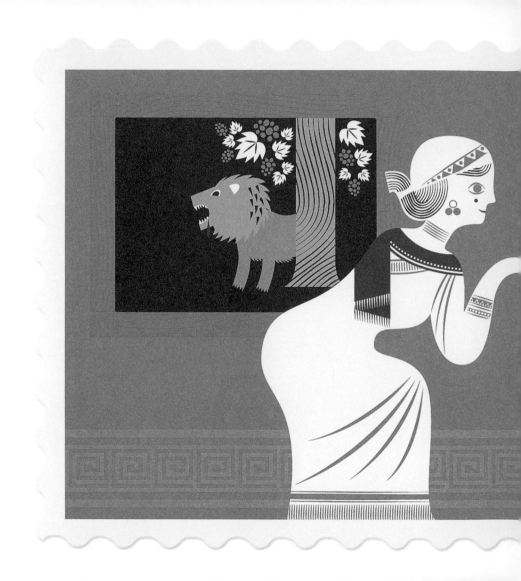

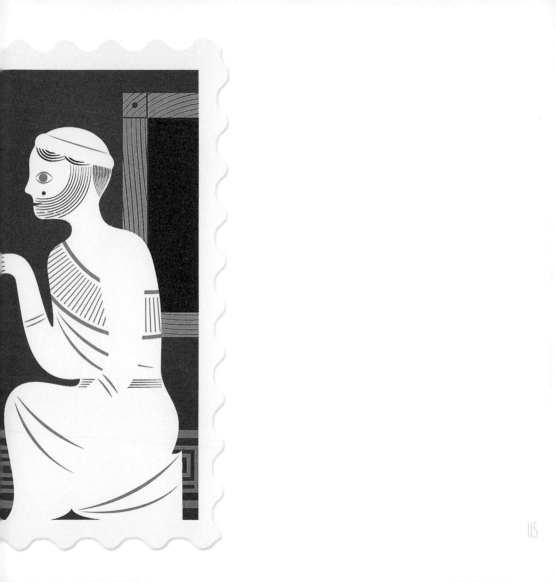

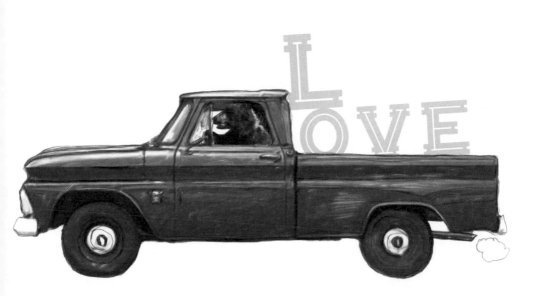

all you need is love.

IMAGE CREDITS

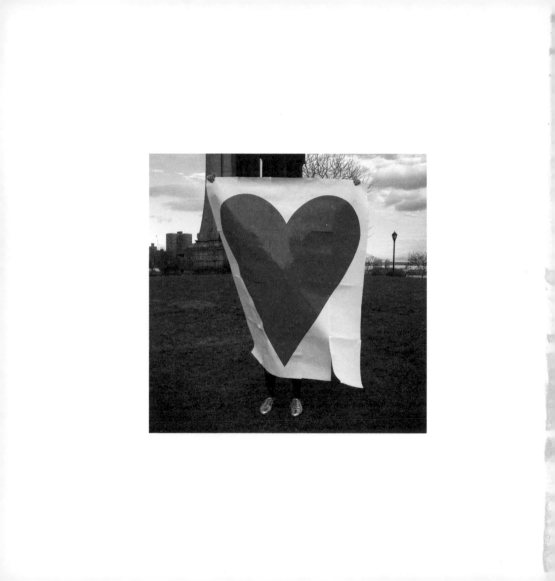

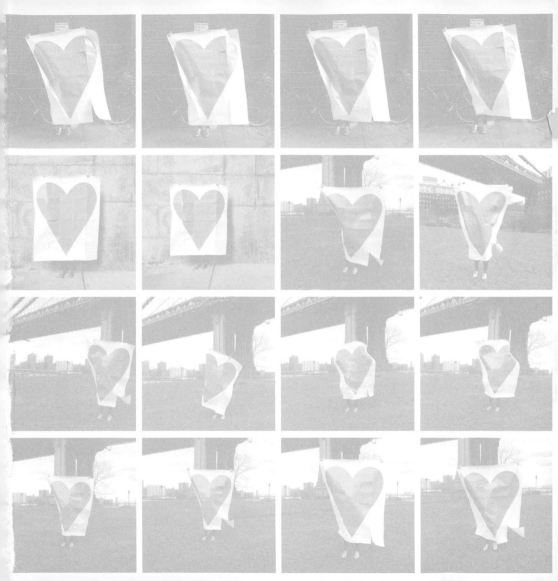